Ernie

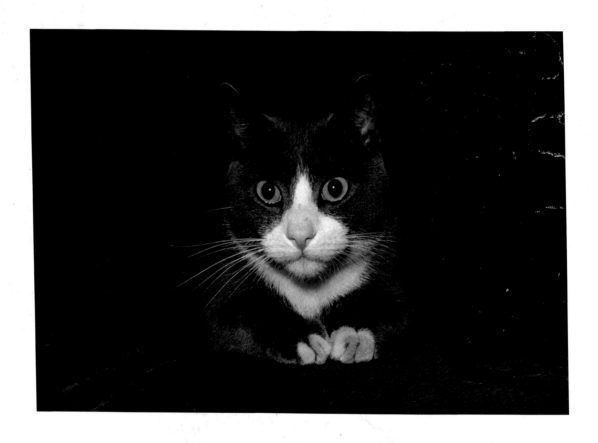

Ernie

A Photographer's Memoir
Tony Mendoza

CHRONICLE BOOKS
SAN FRANCISCO

Library of Congress Cataloging-in-Publication Data available.
ISBN-13: 978-0-8118-2963-2
ISBN-10: 0-8118-2963-4

Printed in Singapore.

Designed by **Sara Schneider**

Distributed in Canada by Raincoast Books
9050 Shaughnessy Street
Vancouver, British Columbia V6P 6E5

10 9 8

Chronicle Books LLC
85 Second Street
San Francisco, California 94105
www.chroniclebooks.com

FOREWORD

Ernie: A Photographer's Memoir was originally published in 1985. It went out of print in the early nineties. Since then, I kept hearing from many *Ernie* fans— where could they get another copy? Their original book was falling apart, or a friend wanted a copy, or they wanted it for a gift. I was surprised and pleased how the book was still sought after, but I couldn't help them. Then I read a reader's comment online that started this way:

"Now incomprehensibly out of print, Mendoza's *Ernie* photos are easily the best photo collection on an individual cat."

I wholeheartedly agreed and set out to remedy the "out of print" situation. My first choice for a new publisher was Chronicle Books and they were as excited about this project as I was. This new and improved edition of *Ernie* features better printing than the first, so the quality of the original prints really shines through. We also added fourteen pictures that did not appear in the original book. You'll also find some never before published thoughts from **Ernie** himself. I'm thrilled with this edition and very happy that *Ernie* is alive and scratching again.

—Tony Mendoza

Nancy and I are loftmates. Nancy is now looking for another loftmate, a human, willing to share the loft and the rent. The rents in these lofts are criminal. So I say, fine, bring someone in, someone who can pay some rent and operate a can opener. Someone who knows his place. Nancy is an artist. She used to paint but now she makes sculptured cakes. She has very good taste. For example, she chose me.

I'm Ernie.

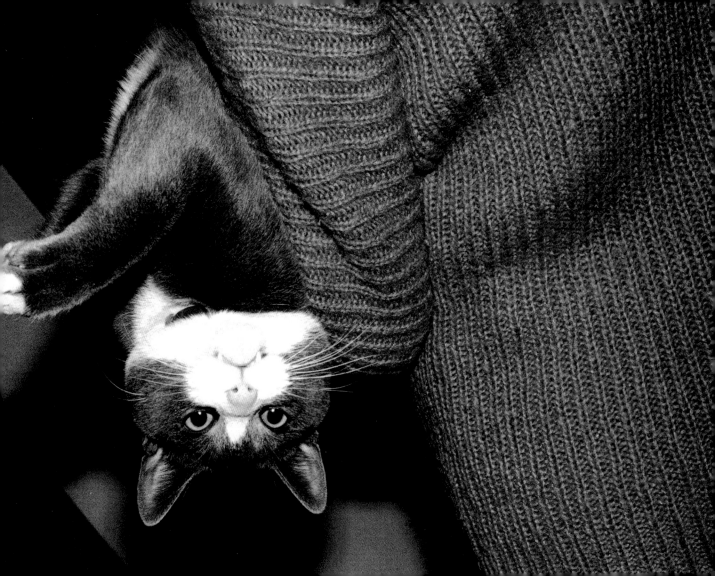

When I arrived in New York City, determined to make a name for myself in the art scene, I had a carload of photographic equipment, a trunkload of dreams, and no place to stay. I posted Xeroxes all over downtown Manhattan, looking for an inexpensive loft. One day I noticed someone else's ad:

"A painter wishes to share a darkroom-equipped loft with another artist."

I rushed to the nearest phone.

"Hello," a woman's voice answered.

"Hello. My name is Tony Mendoza. I'm a photographer and I just saw your ad."

"Are you allergic to cats?"

"No. I don't think so. You have a cat?"

"Do I ever!"

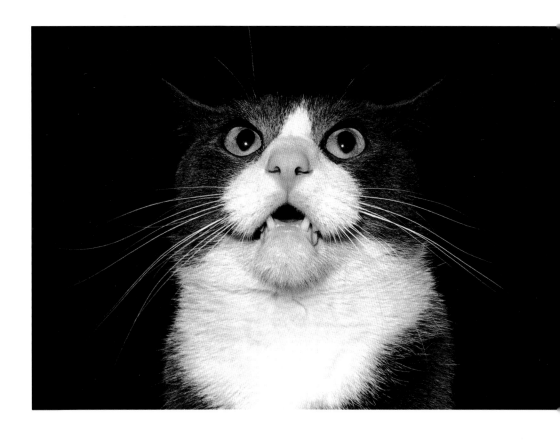

So this guy shows up and we interview him. I know he's right the minute he walks in. His socks are delicious. I grab on and hold his ankle to my belly, till Nancy has to pull me off. He tells Nancy what a handsome cat I am. Says he'll take some pictures of me. I'm thinking: Sure. Why not? I could use a portfolio. My mind is made up. I vote yes. Now it's time to turn on the charm. I show off my jumping skills. I chase a few bugs. I show him my latest bird. I chew lovingly on Elephant.

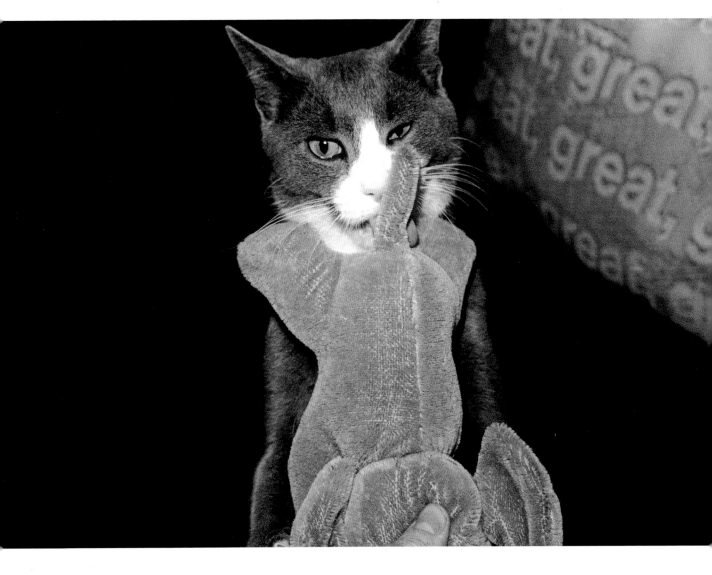

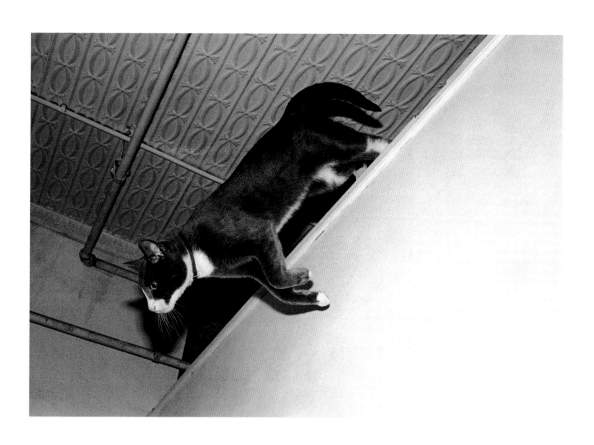

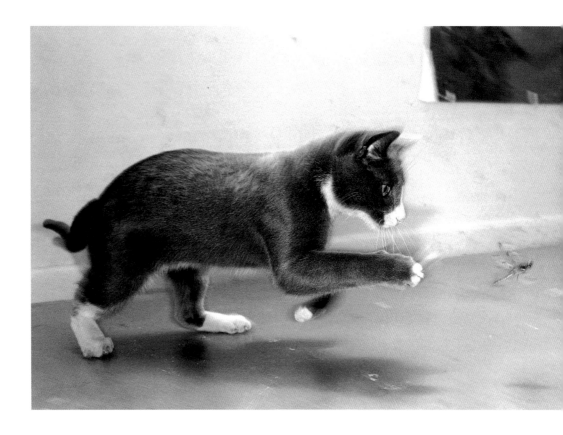

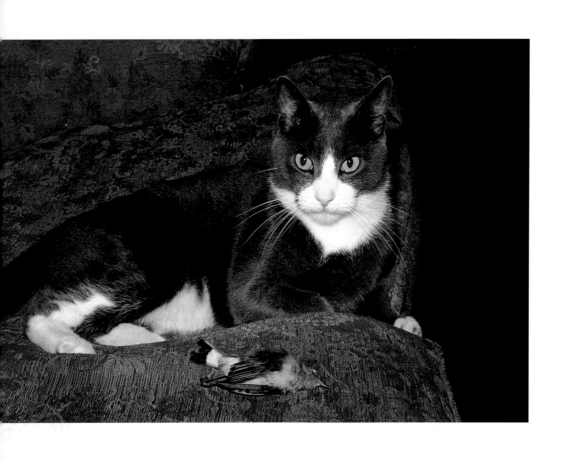

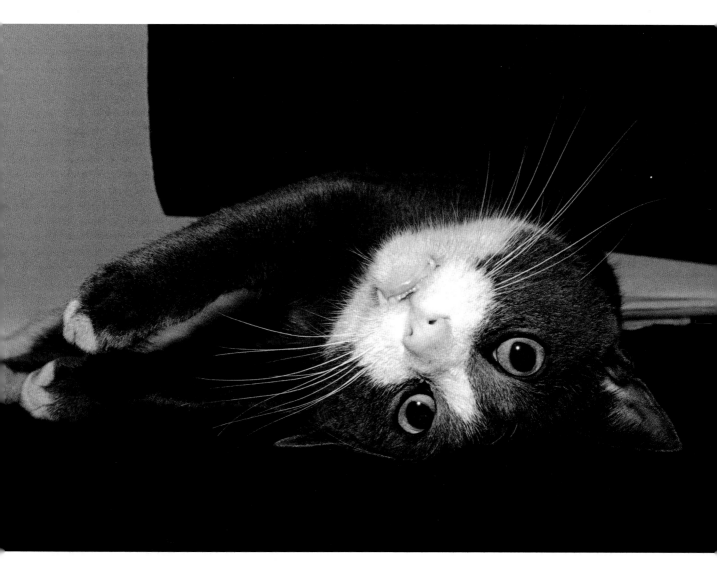

When I first moved in, I couldn't afford to go out, so I got to spend a lot of time in the loft with **Ernie.** I had never lived with a cat before and I was quickly seduced by his personality, his energy, his catness. Were all cats this crazy? His gray and white markings were perfect for black-and-white photography.

I grabbed my camera and started taking pictures.

The new guy moved in. He's got some strange habits.

He spends a lot of time on all fours, crawling after me.

Says he likes to take pictures from a cat's-eye level.

OK. I'll buy that. What I don't like is that every time I

wake up from a nap, there he is, two inches away from

my face, clicking that box at me.

It used to be more private around here.

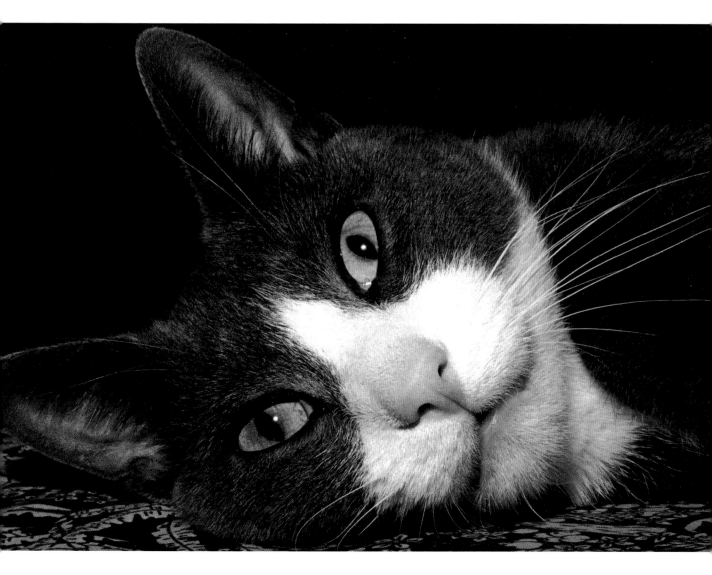

The new guy is getting on my nerves. He talks to me in this God-awful high voice humans use on babies and pets.

All day long it's:

 "Over here, Ernito. You look splendid today. Come

 on, Erniti. Ernititi. Give me a smile. Beautiful.

 Hold it! Now let's try something different, some-

 thing more animal. A little more claw, a little

 more fang. Beautiful!"

Brother.

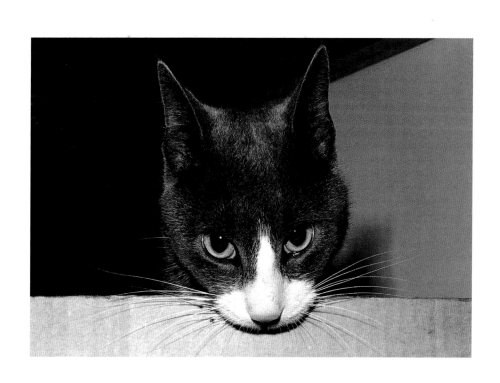

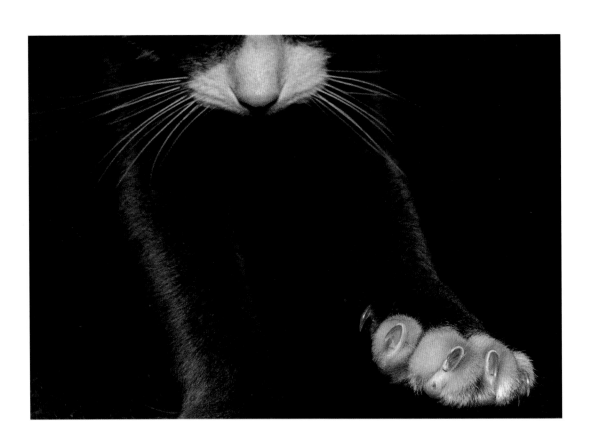

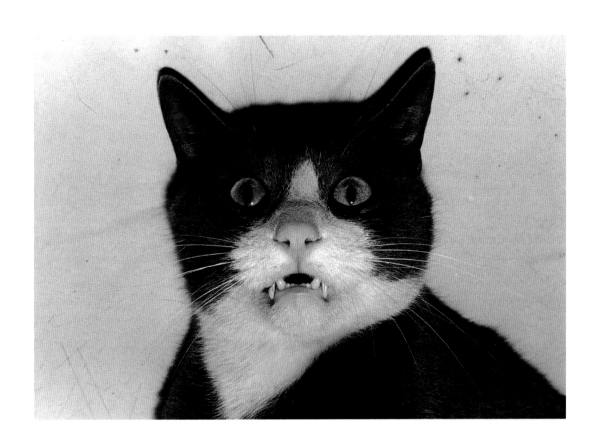

Ernie was a born predator. A part of him seemed to long for his ancestral jungle home. Every morning he would go out on the roof outside the kitchen and stalk the pigeons who sat on the roof's edge. He did this every morning for two years, but he never got close.

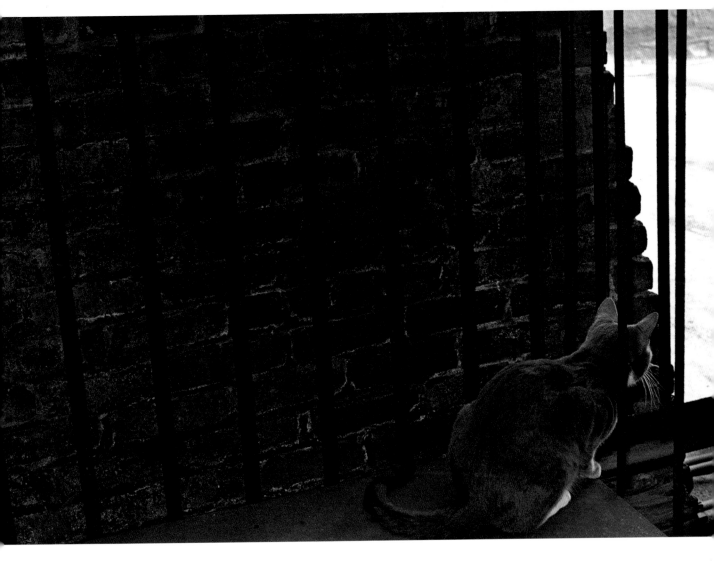

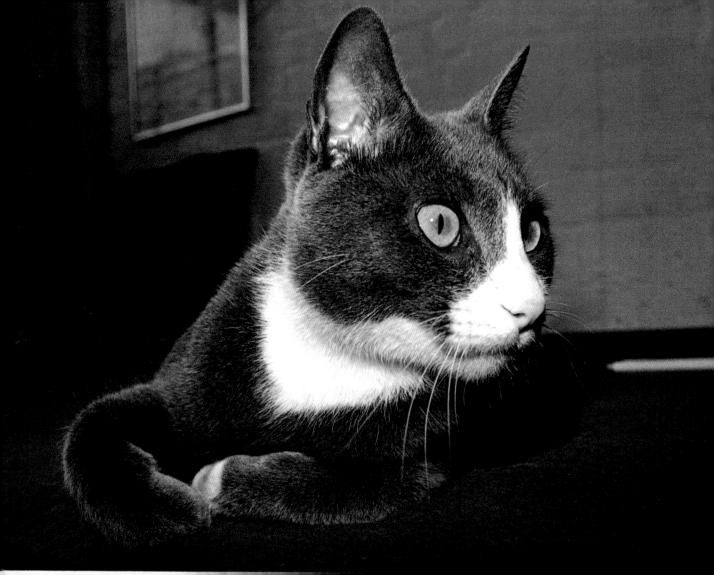

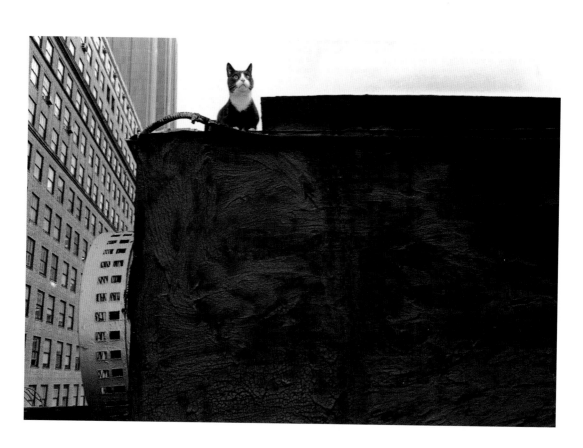

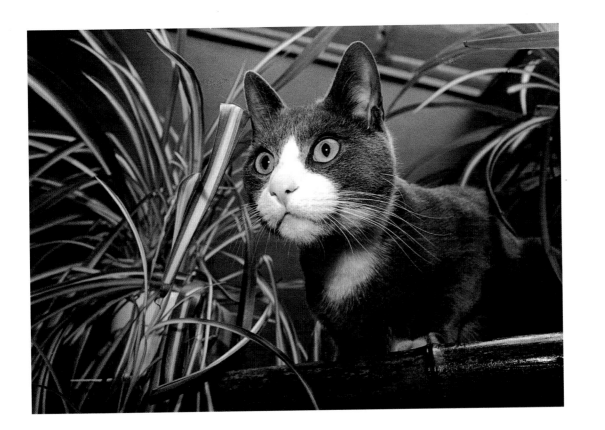

I was never too serious about the pigeons.

Have you ever tried to eat a New York City pigeon?

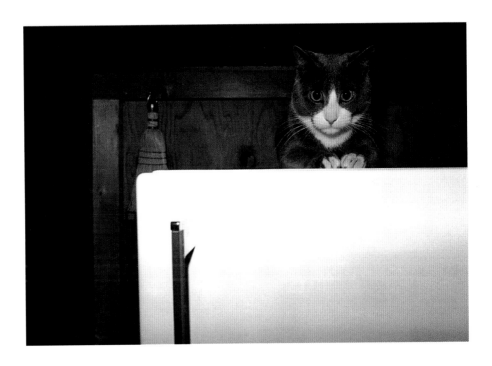

He terrorized all the insects that strayed into the loft. He could snag a dragonfly in mid-flight. In fact, he kept our loft so bug-free that I occasionally had to import a cockroach to give **Ernie** something to practice on.

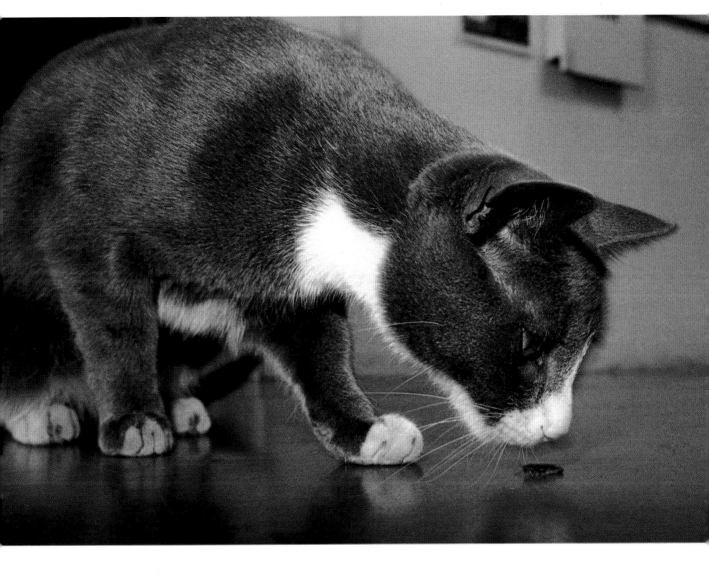

There's not too much wildlife in this loft. Very few mice, I'm sorry to say. A soon-to-be-deceased bug will fly in every now and then. The roof at night is more promising.

Some shadows move.

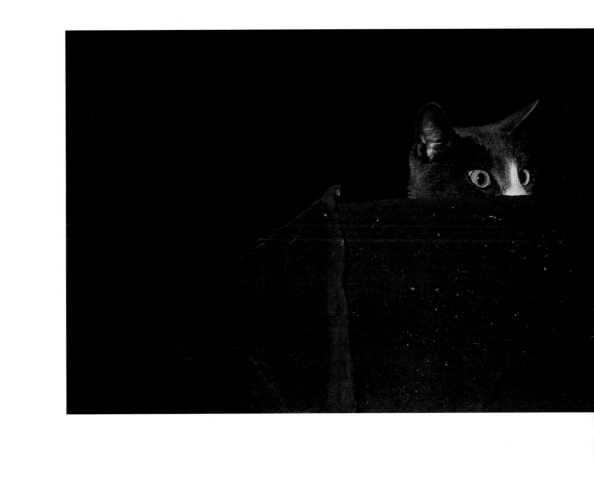

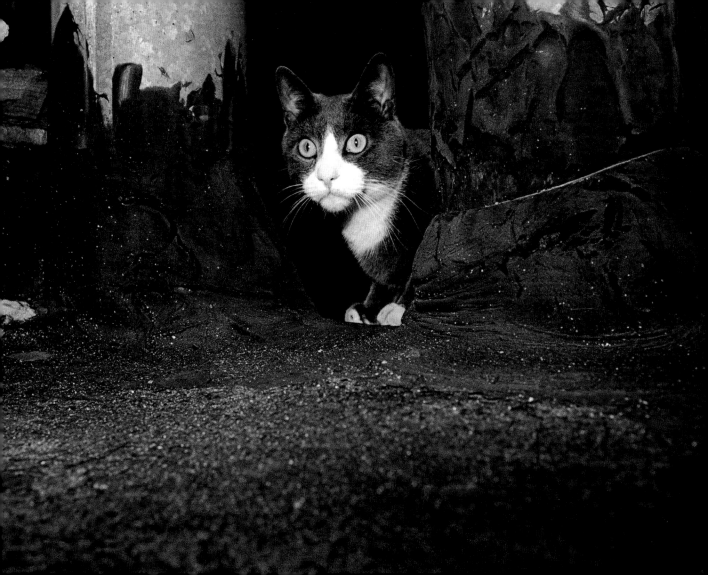

Birds come in all flavors.

This last one was not a great bird.

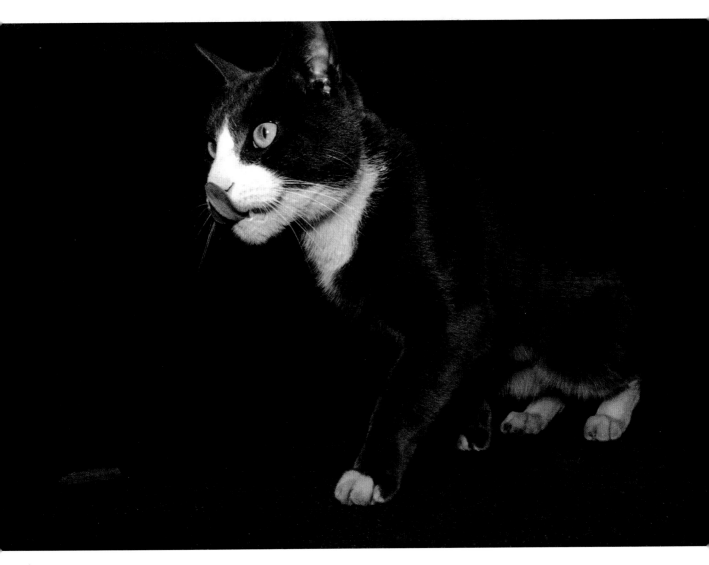

We're going to have to have a little talk. When he brings home a cockroach for me to deal with, that's one thing. I go along. It's not what I would prefer, but it pays to keep your instincts sharp. But then he brings home this stray cat! That's where I draw the line. This is my home we're talking about. Please.

And I won't even mention the time with the dog.

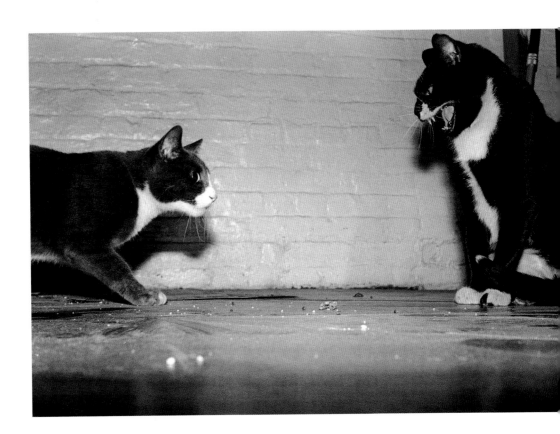

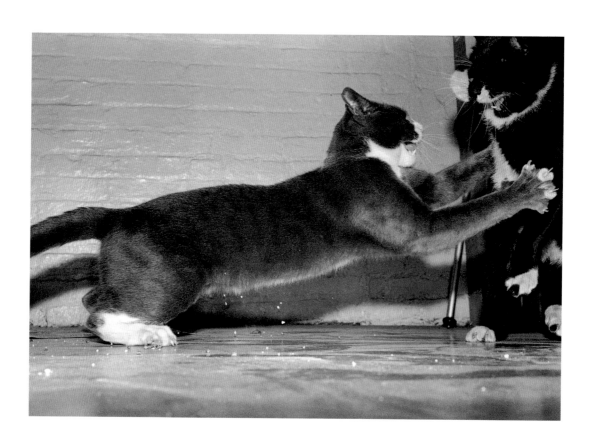

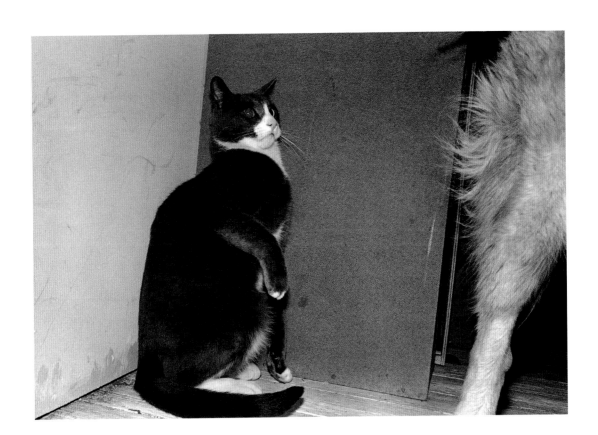

We played this game: "Hand Combat." I would place my left hand on the back of the couch and **Ernie** would run into position on the floor in front of the couch. He would crouch down, wiggle his behind a few times and then spring for my hand (while I took pictures of **Ernie** in mid-air). I would pull out my hand at the last moment, and win the game, but often, **Ernie** was quicker, and he would win. For two years I wore battle scars on my left hand.

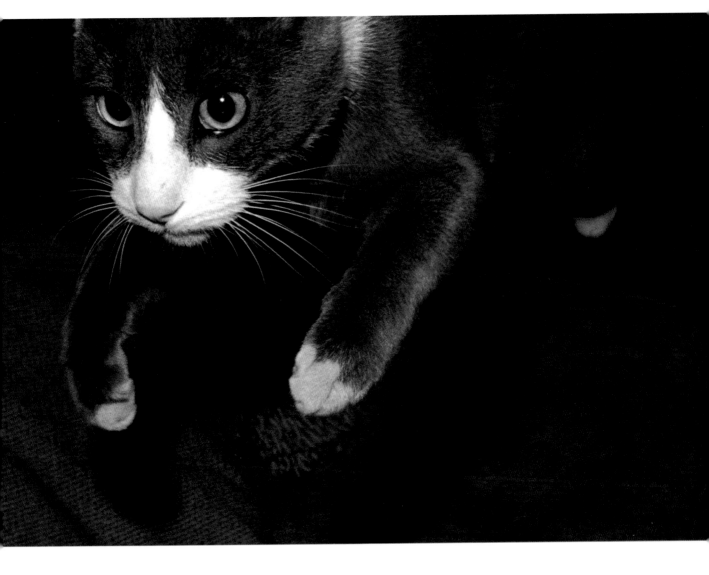

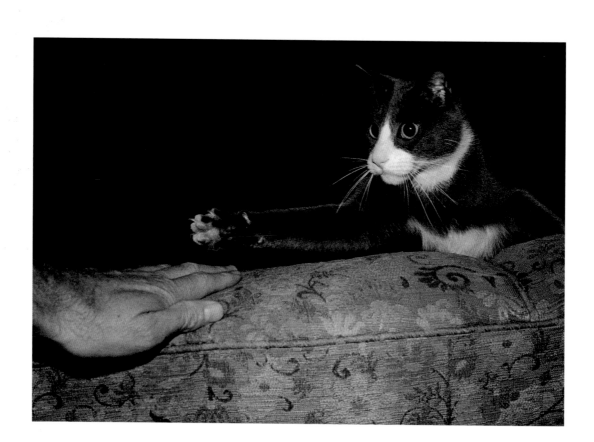

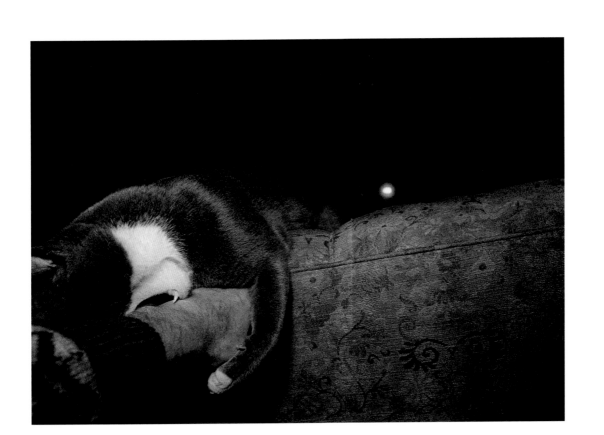

We have an understanding:

 I'm no cuddly, cutie-pie cat. There are plenty

 of those around—posing for birthday cards

 and calendars.

 Basically, I'm fierce, and he knows it.

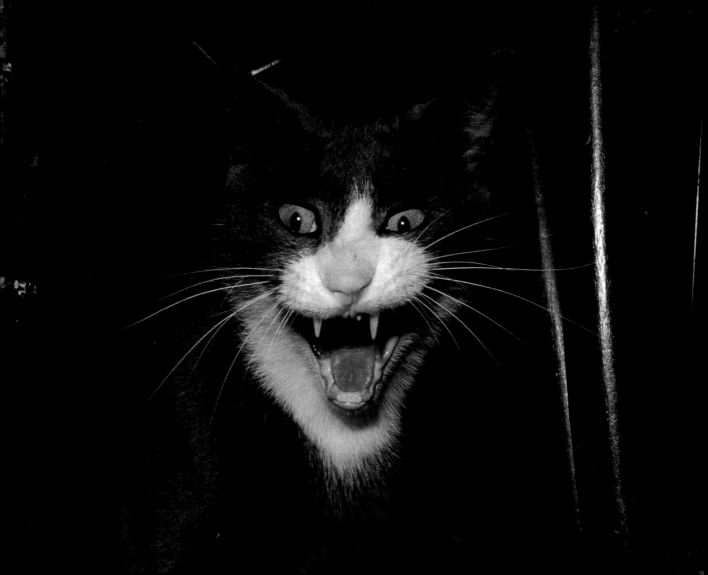

The humans in this loft are giants. On the other hand, down there on the street, they are tiny.

I wouldn't mind having a few of those up here.

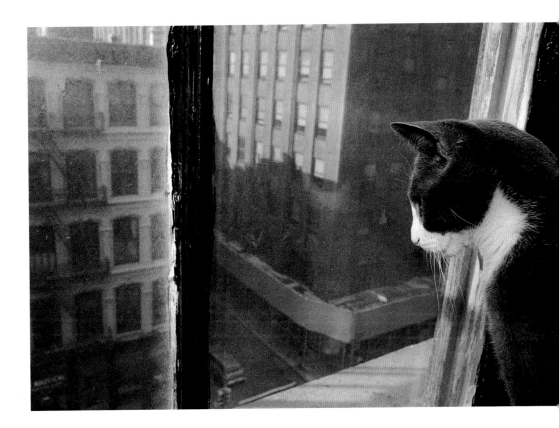

Most of the time, though, **Ernie** kept busy just being a cat.

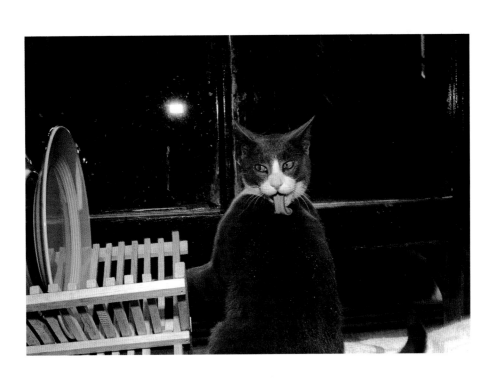

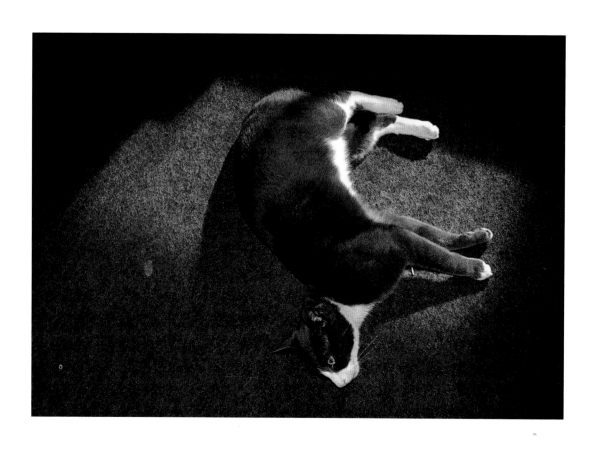

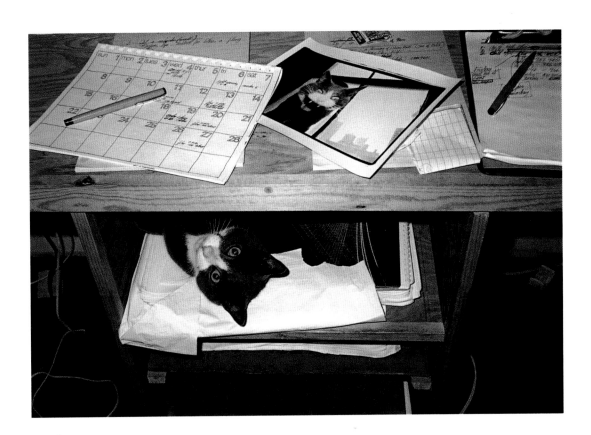

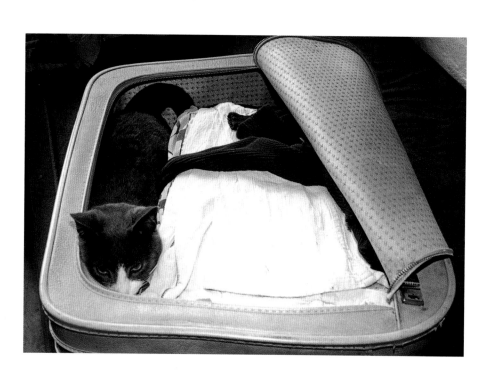

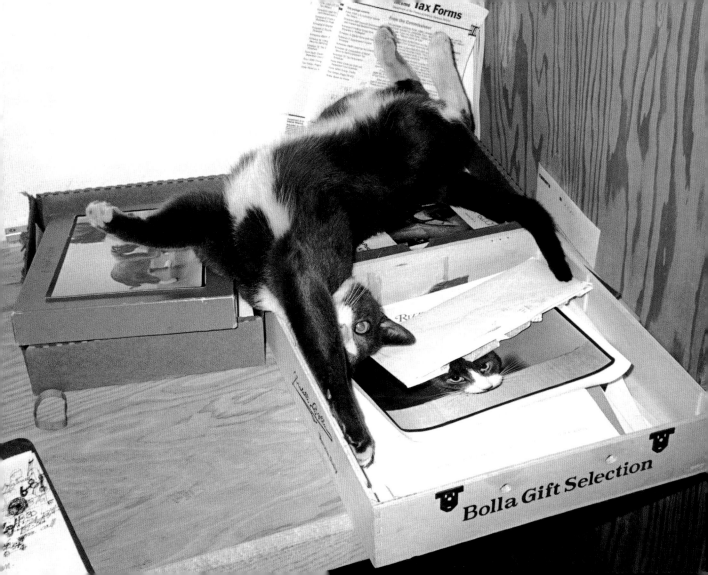

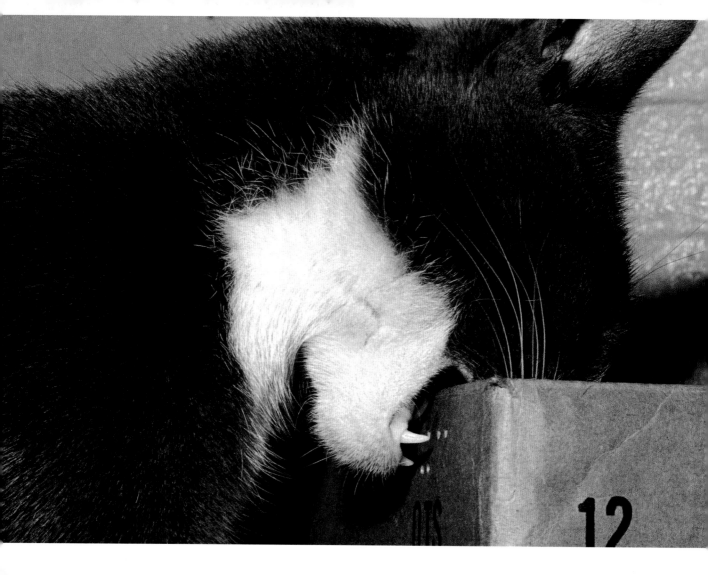

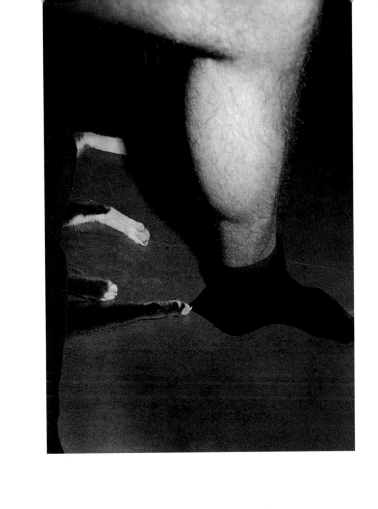

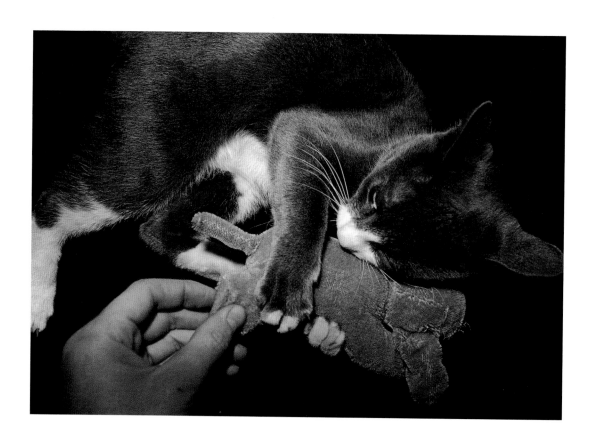

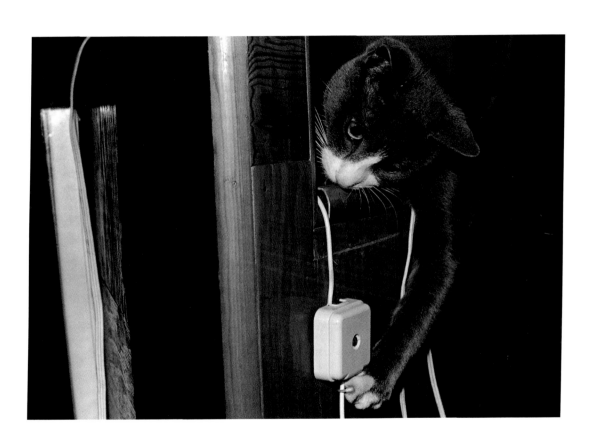

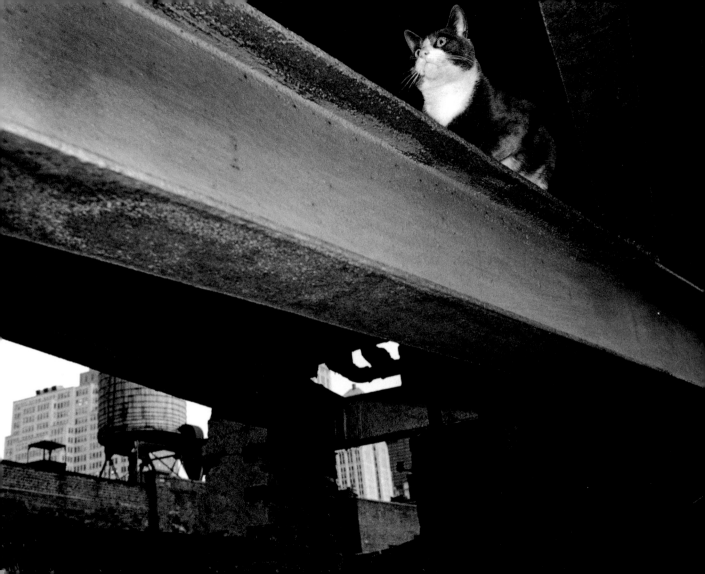

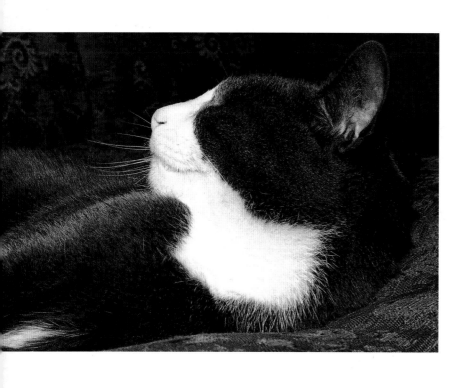

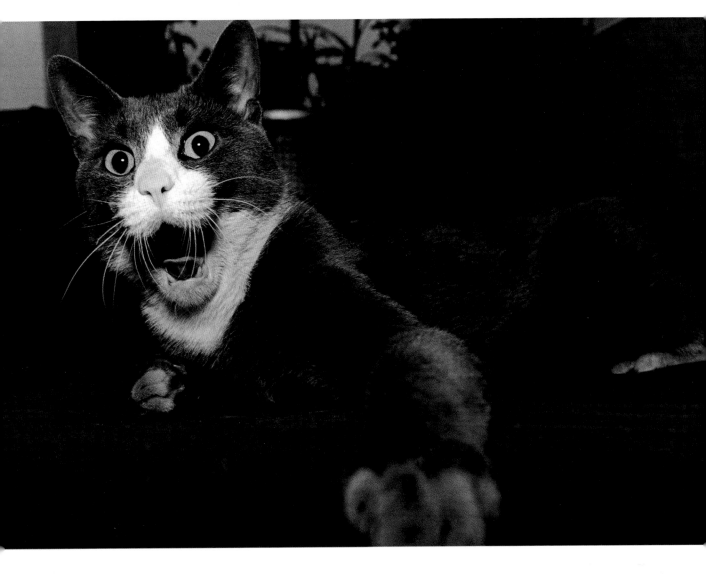

I have a lot more to do now that I'm

a photographer's assistant.

I pose.

I make suggestions for new shots.

I help him look at pictures.

I help him in the darkroom—he doesn't

see so well in the dark.

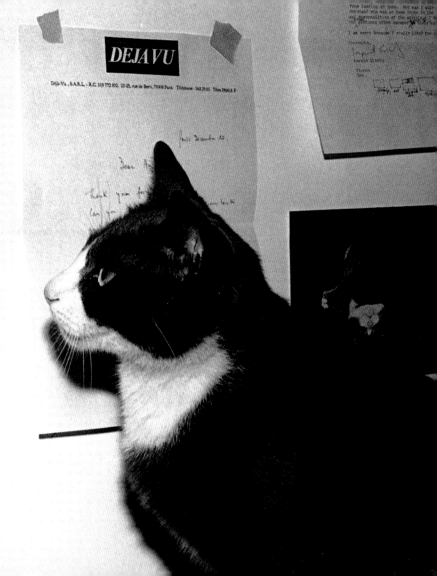

DEJAVU

Déja-Vu, S.A.R.L. - R.C. 319 772 802, 23-25, rue de Berri, 75008 Paris. Téléphone: 562.29.11 Télex 290616 F

conn

Ordinarily, I don't quarrel with his subject matter.

But every now and then he blows it.

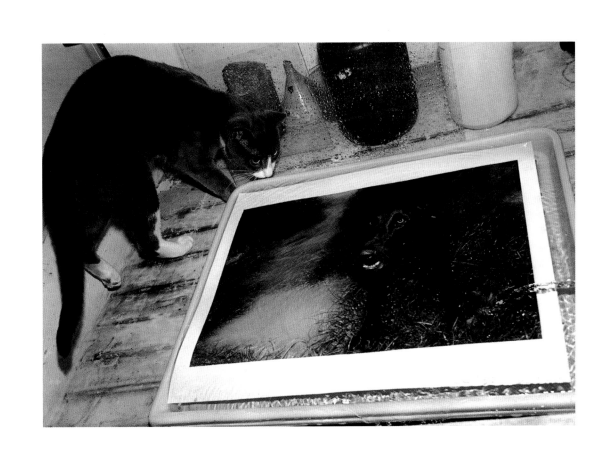

After I had lived in the loft for one year, I had accumulated a few thousand negatives of **Ernie** and a growing list of debts to credit cards and relatives. I realized I had to sell some pictures and make some money. I put together a commercial portfolio—which had become increasingly filled with cat pictures— and took it around to art directors. Most of them said they had no need for cat photographers. After a while, a downtown newspaper called and asked me to do a cat cover. I wanted to use **Ernie,** but was voted down by an editor who insisted on using her own cat.

Ernie's review was not favorable.

EXCLUSIVE: HOURLY MANHATTAN CABLE TV GUIDE

MARCH 1981

SoHoNews

INSTITUTE FOR POLICY STUDIES
PULLING THE PLUG
ON A THINK TANK
Doug Ireland

THE MEOW GENERATION
CAT LOVERS MAKE STRANGE BEDFELLOWS Arnold Klein

WHAT IS THIS THING CALLED 'RAP'? Michael Freedberg
'EYEWITNESS' TOUGH GUY: JAMES WOODS Joseph Hurley
WILL CHRISTO RISE AGAIN? Gerald Marzorati

Ernie started catching on, though. American and European photography magazines published selections. Three postcard companies "Ernied" some postcards. Two museums bought *Ernie* pictures for their collections. I had a one-man, one-cat show. My father came to the show.

"I see you've become a cat photographer."

"I guess so."

"You're crazy. If you want to make money, you should be taking pictures of beautiful women."

"You're probably right, Pop, but in the meantime, I think I'll do an *Ernie* book."

———

Celebrity has not spoiled me. Postcards, magazines, even a book. I'm very big right now. But you can't get too far in print media. My agent and I have other ideas. We're talking film, talking TV. I hear Stephen King has a script about a possessed cat . . .

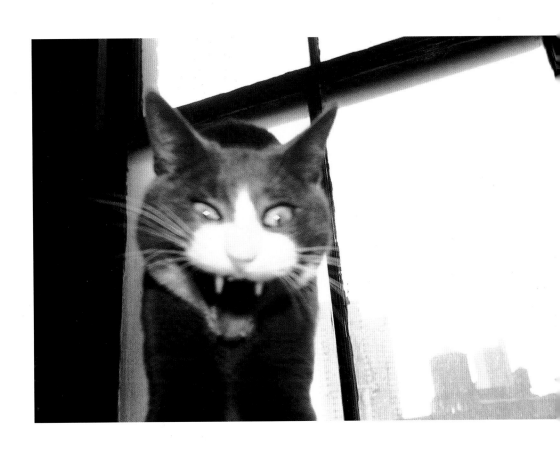

After living in the loft for two years, I moved out. I just couldn't afford Manhattan rent doing cat photography.

———————

All of a sudden, one day there is all this activity: loud strangers tearing up the place, then moving boxes down the stairs. I stay on the roof till the storm is over. And the next day he's gone. He doesn't come back that night. He's gone the day after that, too.

Nancy tells me he moved.

EPILOGUE

He came to visit once.

 So?

I suppose he expected me to chew on his socks. Maybe I

 was supposed to chase a bug. Be cute. Bare my fangs.

 Just like old times.

I ignored him, of course.

Now I hear he's closed a deal on the *Ernie* book.

So far I've heard no mention of any percentage points for

 old Ernie.

―――――――――

I went back to visit Nancy and **Ernie** many months later. I went up to him and made a big fuss, but he just looked at me blankly and walked away. But later, after talking to Nancy for a while, I noticed him eyeing me curiously. I got up casually and put my hand on the back of the couch. **Ernie** sprinted to the front, wiggled his behind a few times, and sprang.

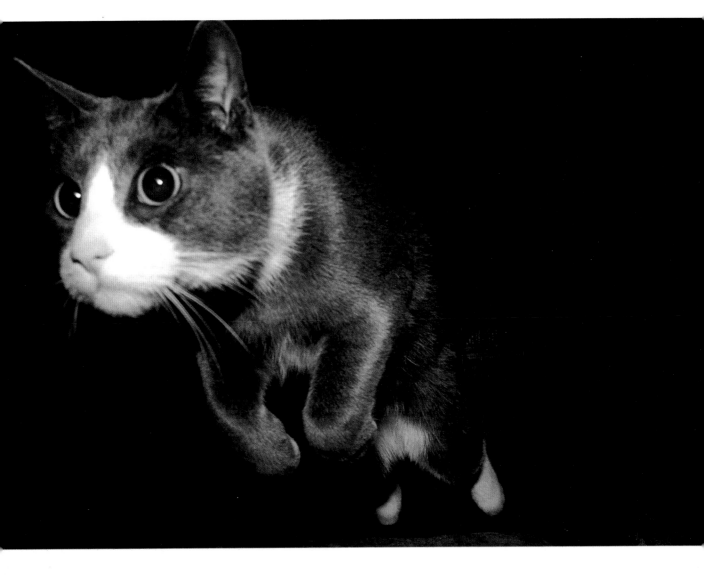

ABOUT THE AUTHOR

Tony Mendoza was born in Havana, Cuba, in 1941. He left for Miami with his family in 1960.

He bought his first camera at age eleven and continued photographing through grammar school, high school, Yale University (Bachelor of Engineering), and the Harvard Graduate School of Design (Master of Architecture.)

In 1973, to the dismay of his creditors and relatives, he turned full time to the pursuit of photography as art.

Since then, his work has been exhibited and published widely. He is the author of five books, including *Cuba: Going Back* (1999), *Stories* (1987), and the original *Ernie* (1985). He has received three National Endowment for the Arts Photography Fellowships, a Guggenheim Photography Fellowship, as well as two Creative Writing Fellowships from the Ohio Arts Council. His photographs are in the collections of major museums, including the Museum of Modern Art and the Metropolitan Museum of Art in New York City. For the past twelve years he has taught photography at The Ohio State University.

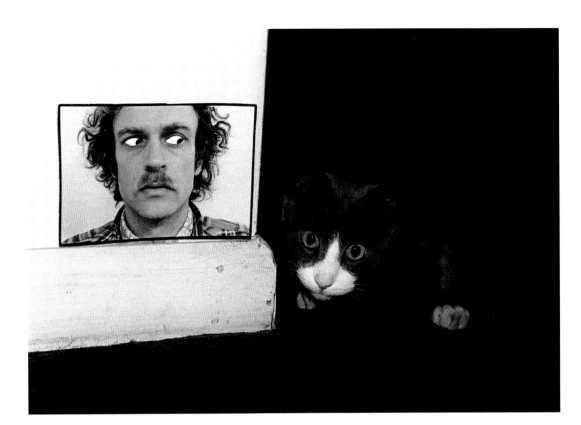

HEREWARD COLLEGE OF FURTHER EDUCATION
BRAMSTON CRESCENT
COVENTRY
CV4 9SW